A LITTLE KOSHER WHINE?

A Little Kosher Whine?

A selection of cartoons by Jeremy Gerlis

VALLENTINE MITCHELL
LONDON • PORTLAND, OR

First published in 2005 in Great Britain by
VALLENTINE MITCHELL
Suite 314, Premier House, 112–114 Station Road,
Edgware, Middlesex HA8 7BJ

and in the United States of America by
VALLENTINE MITCHELL
c/o ISBS, 920 NE 58th Avenue, Suite 300
Portland, OR 97213-3786

Websites: http://www.vmbooks.com
http://www.kosherwhine.com

British Library Cataloguing in Publication Data
A catalogue record has been applied for

ISBN 0-85303-689-6 (paper)

Library of Congress Cataloging-in-Publication Data
A catalog record has been applied for

Printed in Great Britain
by MPG Books Ltd, Bodmin, Cornwall

Contents

Foreword

BY DANNY FINKELSTEIN

Honestly, how difficult can it be? You dash off a line drawing and then add a merry quip. Anyone can do it, surely?

The answers are very and no.

I've done a great deal of commissioning for a number of very different publications. There is a wealth of talent to draw on and you are almost never stuck, 'Can you write 1,800 words by tomorrow about the crisis in the multiplexer industry?', 'No problem Danny.' 'Stephen Byers says he lied to Parliament, but can't remember his motivation. Can you make a suggestion stretch to 600 words?' 'Be with you in an hour Danny.'

But try commissioning a cartoon and it's a different story. It turns out to be very hard to find someone who can draw and make a joke at the same time. There are plenty of people who want to be cartoonists who can't do either, believe me.

And this is all a bit of problem, because I love cartoons. Certainly I love them more than I love 1,800-word features about multiplexers. The best can sum up an entire argument with just a few words and a simple image, making you laugh at the same time.

I've been very lucky on *The Times*. Some people disagree with Peter Brookes sometimes, but no one seriously doubts that he is one of the cartoon greats. And I am fortunate too on the *JC* to be a colleague of Jeremy Gerlis.

This point would hardly need making if I was writing an afterword. Once you have flicked through this book you will see clearly for yourself Jeremy's talent.

So what are you reading this for?

Danny Finkelstein is Associate Editor of The Times *and a columnist on the* Jewish Chronicle.

Four Questions

This book offers no history of Jewish humour nor any insight into that major bridging role of Jewish artists/publishers in the art form that is comics and cartoons,* just a simple clue to the second most asked question of any cartoonist, 'where do you get your ideas from?'**

In the seven years that I've been drawing cartoons for the *Jewish Chronicle* I've developed a theory that, whilst it's not entirely necessary for a cartoonist to draw funny, it's very useful that they can *hear* funny.

Words and phrases misheard, mixed up and punned upon form the basis of most humour and cartoons are no exception – handy, given the perceived lack of suitability of many of the *JC*'s lead items for cartoons.

My starting point is always the words – I think of words to do with the subject or to connect two subjects, say them, write them down, misspell them, alliterate them, debate with the dog and do it all over again.

Then I come up with a phrase or two (bear in mind the difficulty of lengthy dialogue in a single small frame), do the gag and when it sounds right that's when I sketch the cartoons, drawing upon years of experience with my quivering quill and submit four ideas to my editor.

There's plenty of examples to support this theory reproduced here – 'Kosher Whine', 'Oy Ge Vault', 'Carol Singer', 'Rice and Peace', 'Book of Revelations', 'High Jump', 'Occupied Underpants', 'Abba's' …

To answer the fourth question, my personal favourite is probably 'You've Got Hail' for its simplicity (less is more, as my agent might say, if I had one).

* read 'Kavalier and Clay' by Michael Chabon, Picador USA
** 'yes, but what do you *really* do?'

Each cartoon has its own context and story, but here's just one extra little tale – my introductory cartoon back in 1998 shows me and Strudel posing together, but in the published version the *JC* cut off the end of her tail; the only way to pacify her was to put it back in and if you look closely you'll see it crop up in minute detail, usually bottom left corner, in many of the earlier cartoons (hey kids! – there's a Strudel's tail in 24 of the cartoons – see how many *you* can spot!!).

Jeremy Gerlis
September 2005

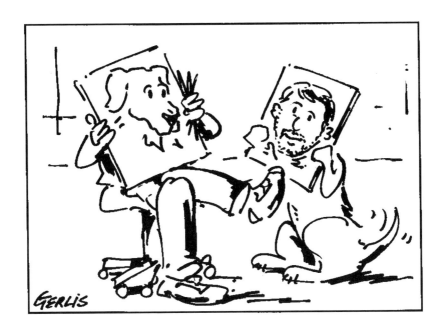

9

Table Plan

I was amazed at the number of actual personalities and characters whose features we've featured over the years (at the time of writing) – for anyone still reading this is the most complete list I can manage, in a totally random order:

David Dein	Monica Lewinsky	Bob the Builder
Sharon Osbourne	Pope John Paul II	George Bush
Louis Walsh	Gary Lineker	Sven-Göran Eriksson
Yassir Arafat	Peter Snow	Mordechai the Jew
Ariel Sharon	Abu Hamza	Esther, his Niece
Edwina Currie	Tony Bennett	Mad Max
Gordon Brown	Mel Brooks	Ali McBeal
Tony Blair	Uri Geller	God
Cherie Blair	Marilyn Monroe	Winnie the Pooh
Jerry Springer	Barry Manilow	Roo
Boris Becker	Steven Spielberg	Mike Tyson
Michael Howard	Don King	Darth Vader
Queen Elizabeth II	Mahmud Abbas	Jeremy Gerlis
Prince Charles	Madonna	Strudel
Duke of Edinburgh	Charlie Dimmock	Carol Caplin
Camilla Parker Bowles	Edgar Davids	Snoopy
Sol Campbell	David Beckham	Santa Claus
Wayne Rooney	Alex Ferguson	Louis Jacobs
Arsene Wenger	Emile Heskey	Jeremy Rosen
Simon Cowell	W.G. Grace	Orla Guerin
Diego Maradona	Dr Jonathan Sacks	The Messiah (voice of)
Kevin Keegan	Ken Livingstone	

Most featured real personalities: Tony Blair, Yassir Arafat, Ariel Sharon
Most featured characters: God, Phyllis Nisbaum (both omnipresent)

Seymour Gerlis

www.kosherwhine.com updates on shows, talks etc., and lets you email cartoons in this book to friends.

www.thejoblot.com the world of the urban workplace and the characters who disfigure it.

Originals from this book and the *Jewish Chronicle* have and will be exhibited from time to time – they are all available to purchase, just contact me through the website.

My Bar Mitzvah Speech

I'd like to thank Frank Cass my publisher, Jenni Fraser and Ned Temko for my start in cartoons, Gerald Jacobs and Jeff Barak for their patience, Karen Silver and Jodi Lack for all their help, Jonno, Ben and Strudel for unconditional enthusiasm, Simone my crutch, rock and muse, Alan and Tim who, though neither Jewish nor hardly aware of their contribution, have inspired me, and finally to my parents – this book is dedicated to my Dad.

Jeremy Gerlis
September 2005

Already I'm Tired

The sporting calendar in general provided me with great ideas, from the Olympics to the London Marathon via Wimbledon, Ascot and the Boat Race (I feel a taxi driver gag approaching …), and lots of different sports people, mostly those who were suddenly found to have a half-Jewish paternal great grandfather … never mind, he's ours now.

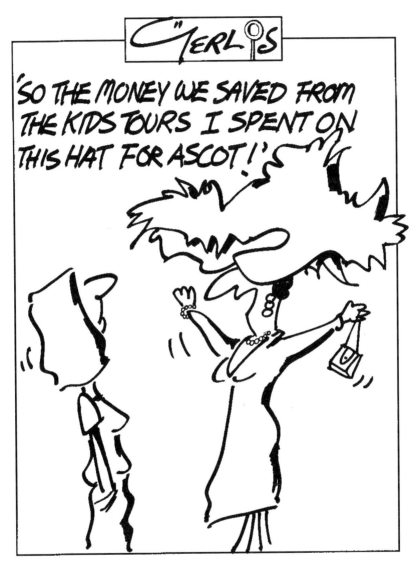

Not enough kids going on organised tours of Israel meant that some could spend more money on hats for the races at Ascot (June 1999)

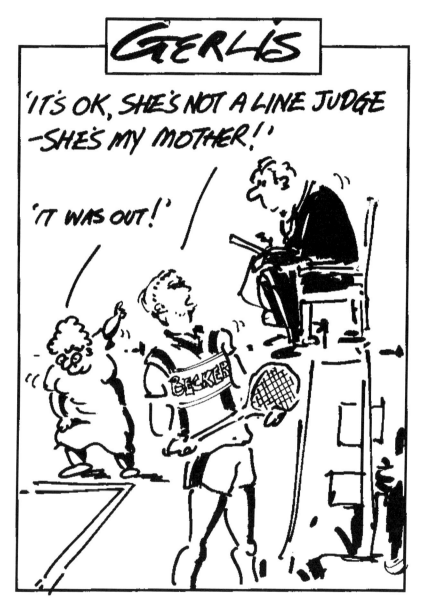

Not a terribly good likeness of Becker, maybe it's better of his mum who is 'discovered' as being Jewish (October 1999)

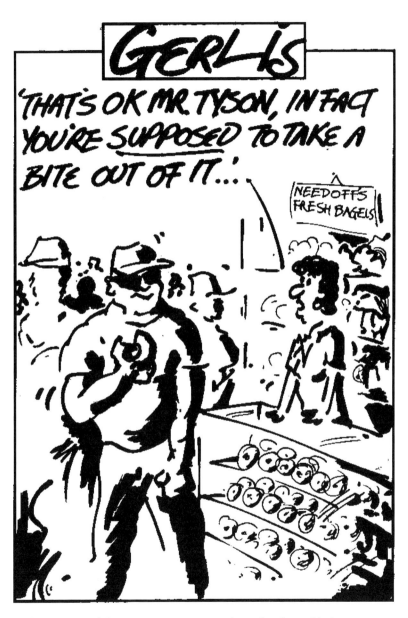

Mike Tyson visited the UK (to great protest) and ate a bagel, possibly from Needoff's, the finest bakery north of Watford (January 2000)

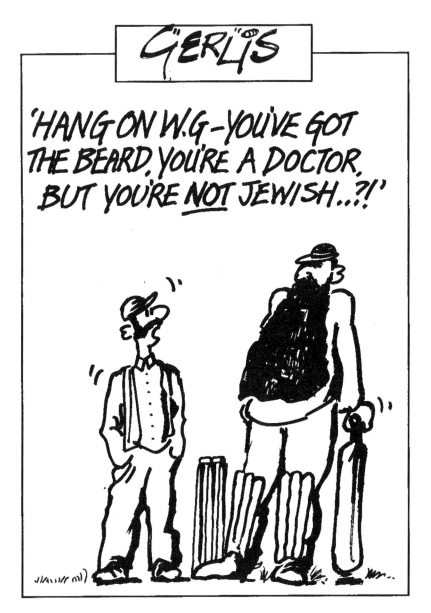

The *JC* find another Jewish cricketer, I'd already done a 'Boycott' gag so we bring old W.G. Grace out of retirement, how's that? (June 2001)

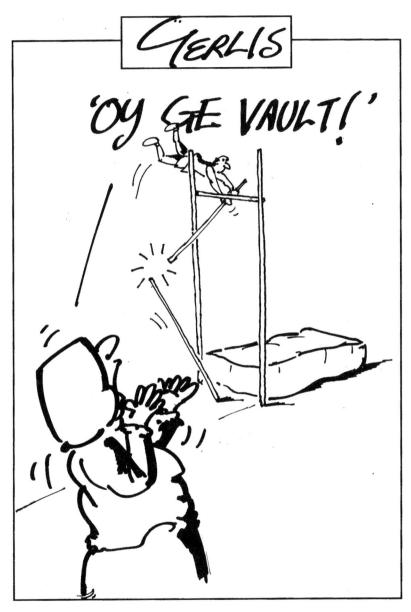

A brilliant effort during the Olympics, and the cartoon's not bad either (and yes, highly original) (August 2002)

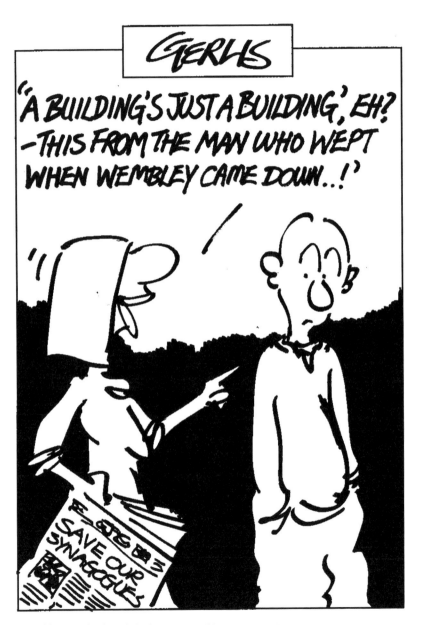

Wembley is to be demolished as an appeal begins to save historic synagogues (February 2003)

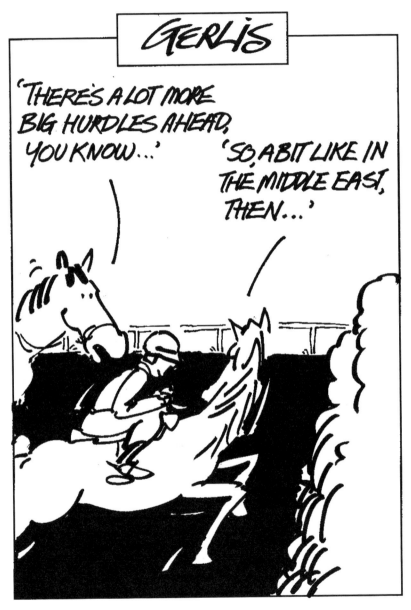

Grand National weekend and yet another dead cert Middle East peace initiative
(April 2003)

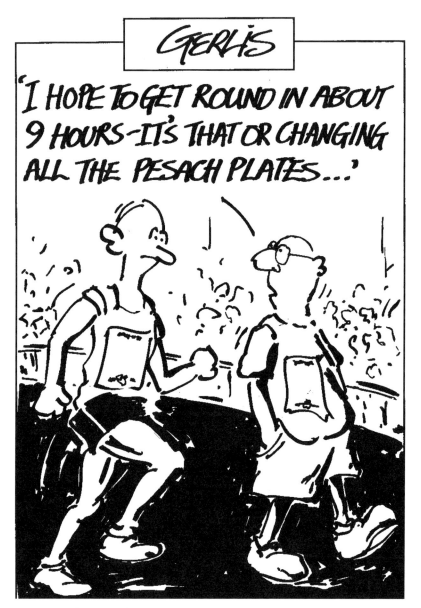

This is one of many I did about the London Marathon over the years, this time happily coinciding with the dreaded chores of Passover (April 2004)

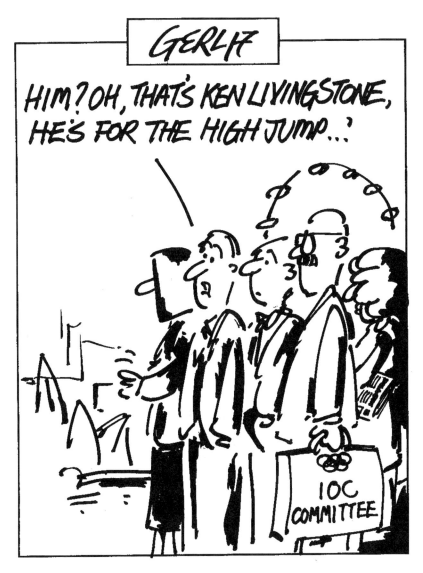

Mayor Livingstone is under fire for insulting a Jewish journalist as the International Olympic Committee come to inspect London and my cousin Rachel turns 17 (February 2005)

Such Big Shots!

I'm not a natural caricaturist (or even a character naturist) but have been proud of most of the efforts to capture 'real' people who we've featured over the years. Here's just a few of them, for a full boring list refer to previous pages.

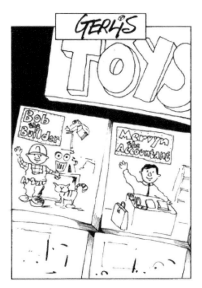

The popularity of Bob the Builder as a Chanukah present is momentarily eclipsed by a new all-action hero, Mervyn the Accountant (December 2000)

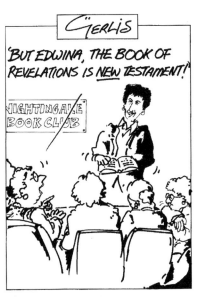

Edwina Currie's revelations in her book don't stop her weekly reading visits to the Nightingales Old People's Home – she bought the original of this cartoon and was most charming (October 2002)

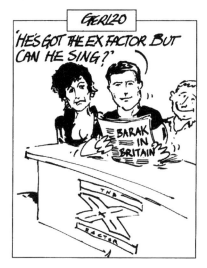

The visit of Ehud Barak to the UK and the popularity of the X-Factor produce some nice caricatures (November 2002)

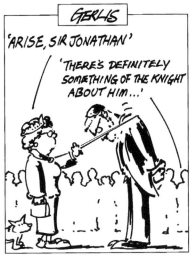

The Queen knights Chief Rabbi Jonathan Sacks (June 2005)

Families and Other Bad Ideas

There's an argument that says that Jewish cartoons are not just about nagging Mums, fat Dads, deaf grandparents, surly teenagers, spoilt kids and cute pets. Then again there's another argument that starts like this, 'You did *WHAT*?!?'

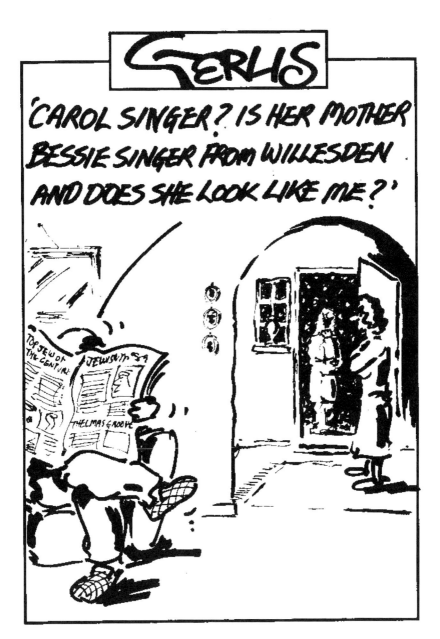

An early attempt at a pun for Christmas 1999 (December 1999)

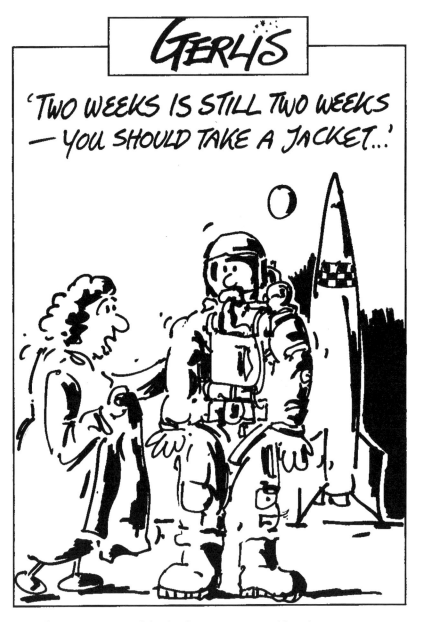

A Jewish astronaut on one of the Shuttle missions … it's cold up there (January 2001)

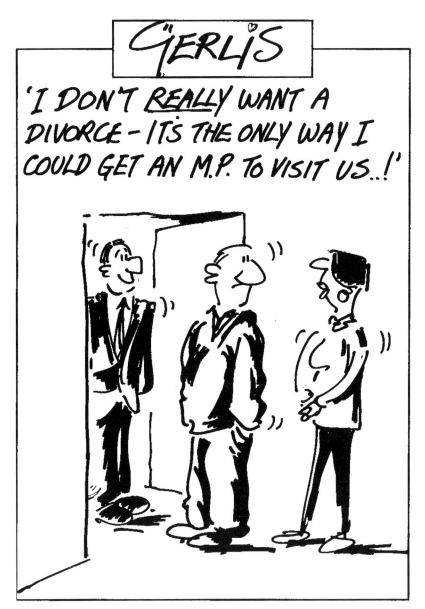

The original of this was bought by Andrew Dinsmore MP, who fights for the rights of Jewish women (July 2001)

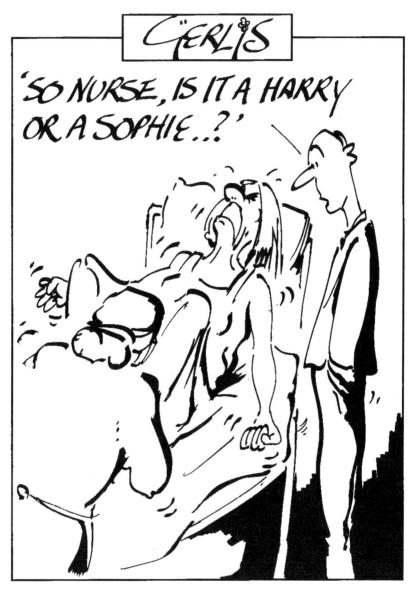

This the more graphic version that the *JC* didn't publish to commemorate the annual letter celebrating the most popular names in the birth announcements (September 2001)

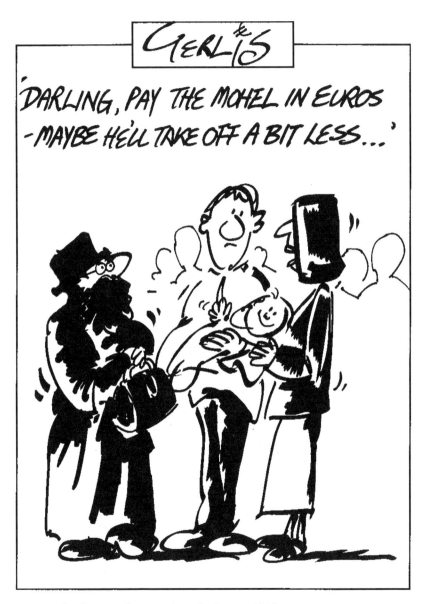

Two gags for the price of one, a snip really (January 2002)

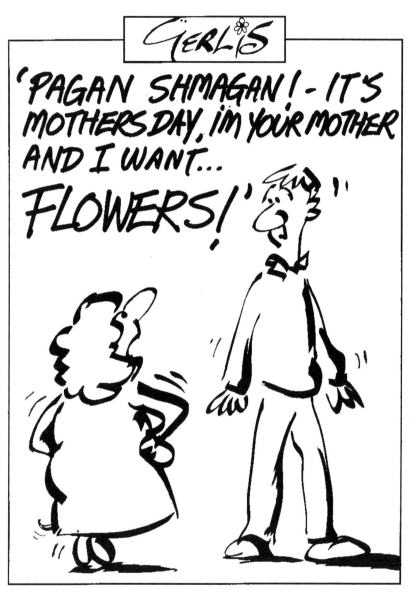

Mother's Day is a pagan festival that nice Jewish boys don't celebrate but their Mums do (March 2002)

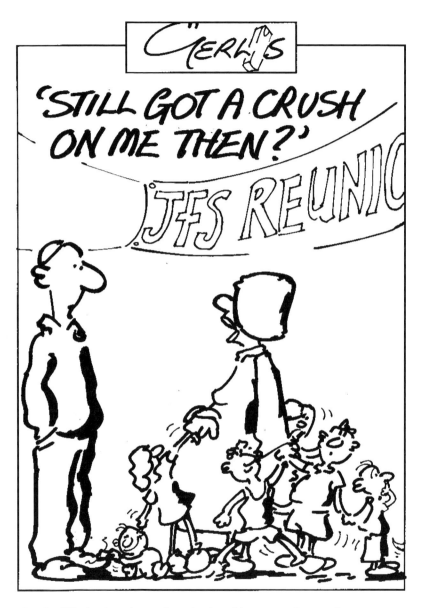

A major JFS school reunion ... time takes its toll but not on the eyes (August 2002)

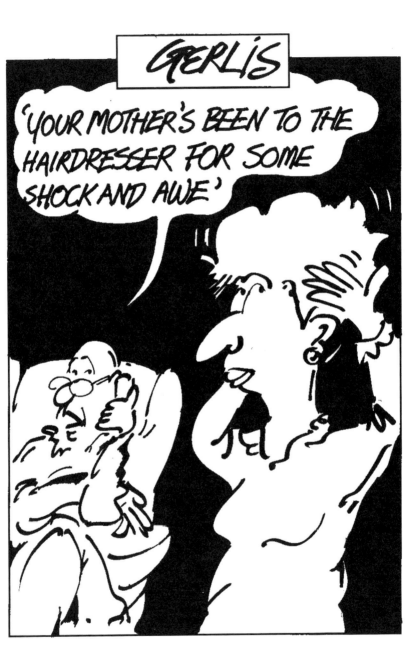

A starring role for Phyllis Nisbaum's hairdo to go with the buzz phrase of the moment (March 2003)

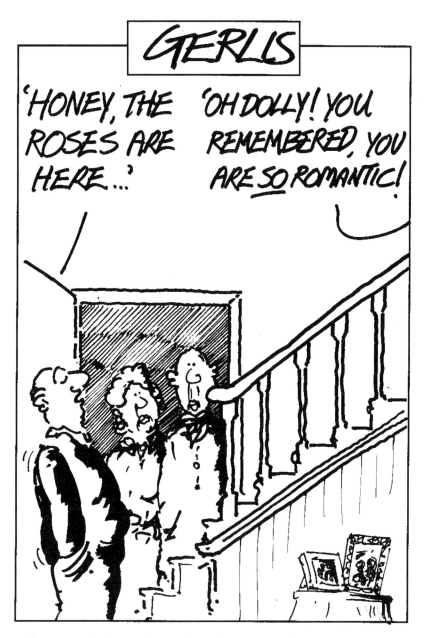

A flower? Another fun pun, this time for Valentine's Day (February 2003)

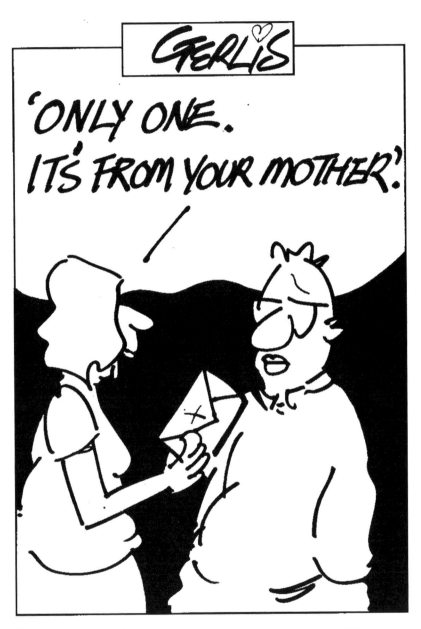

Valentine's Day is a distinctly lonely time for most Jewish men (February 2004)

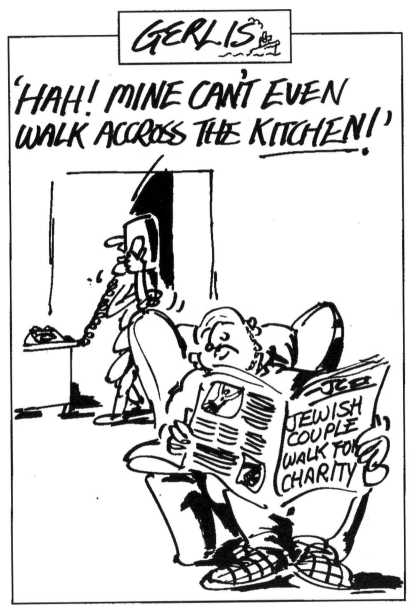

A Jewish couple do a charity walk, the tugboat is in memory of my Uncle Toby ('Tug') who'd just died (August 2003)

This Loyal Toast

A cynical, republican, Jewish cartoonist's view of our favourite tourist distractions, Charles POW in particular provided us with good copy and caricature material over the years. I'd have been a bit crueller but there's the *JC* readership to consider as well as the natural connection of my head to my body.

Charles visits a Jewish school as his courtship is publicly 'acknowledged' (April 2003)

This was drawn and published before the Rugby World Cup Final – check out the drop goal, how accurate is that? (November 2003)

Come the 'big' day and Camilla seeks to reassure Charles (April 2005)

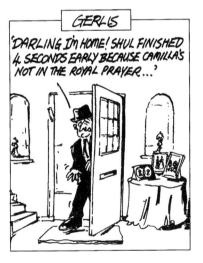

... even then she didn't make it into the royal prayer, she must be gutted (April 2005)

The Feast of the Groaning Table

Chanukah, Rosh Hashanah, Yom Kippur, Pesach, the FA Cup
Final and Christmas – all the major feast days and holy days are
here, each with its own big hat, special book and reserved seat –
the *JC* staff get the days off … but me? Fat chance.

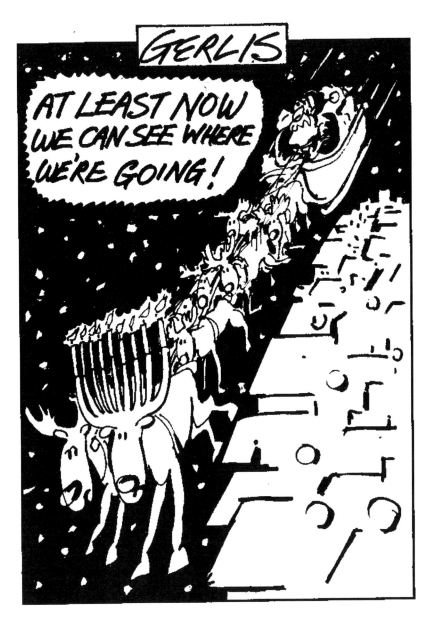

One of the really early ones with daring use of black as Chanukah and Christmas come together (December 1998)

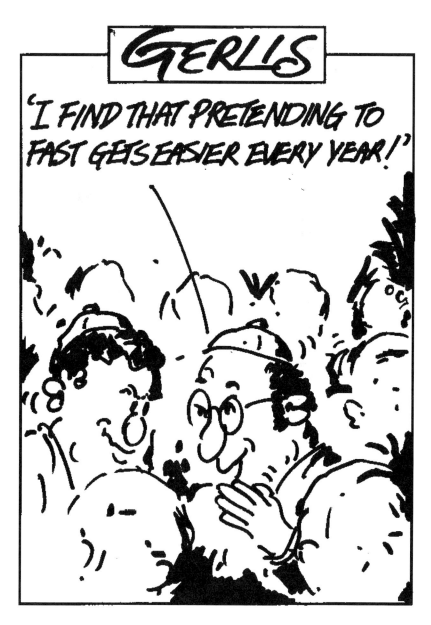

An oldie but goodie for Yom Kippur, I hid a little 50 in here to mark the cartoon's birthday (September 1999)

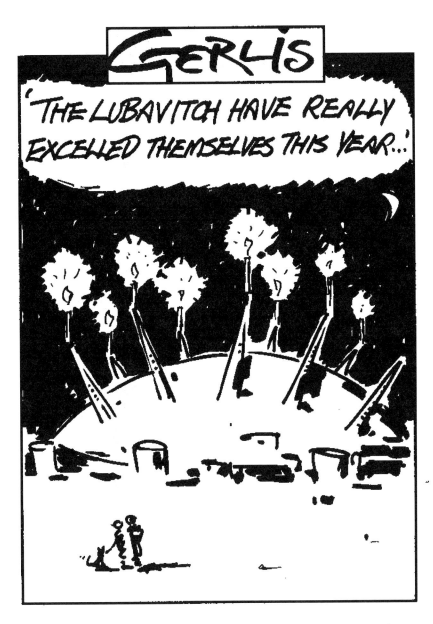

What to do with the Dome after the millennium? The Lubavitch have the answer for Chanukah (December 1999)

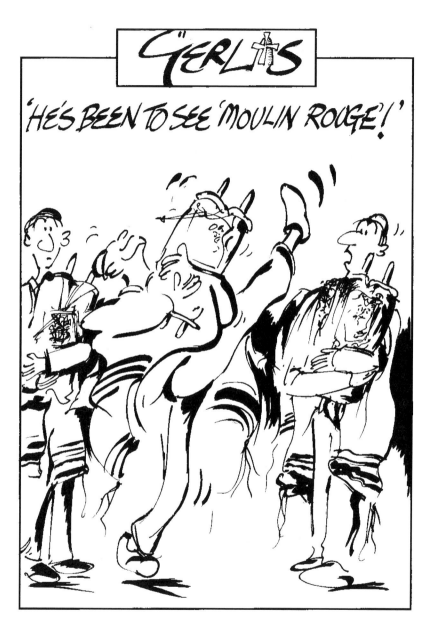

My new italic pen gets an outing as Simchat Torah meets Baz Luhrmann
(October 2001)

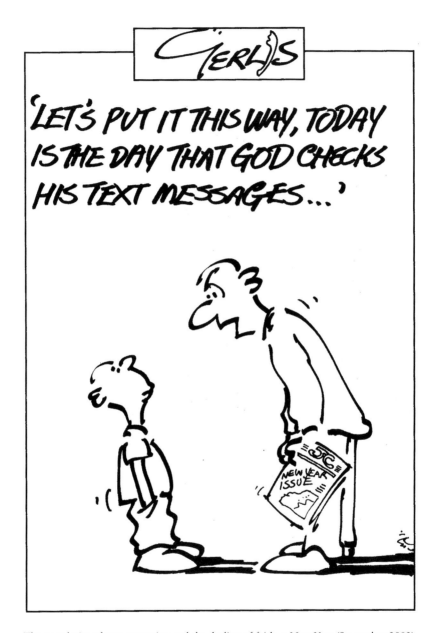

The popularity of text messaging and the decline of faith at New Year (September 2002)

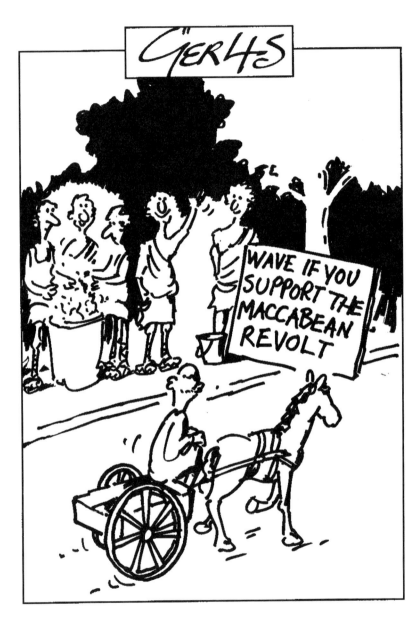

Another favourite, bringing together Chanukah and the firemen's strike, the cartoon was four years old (November 2002)

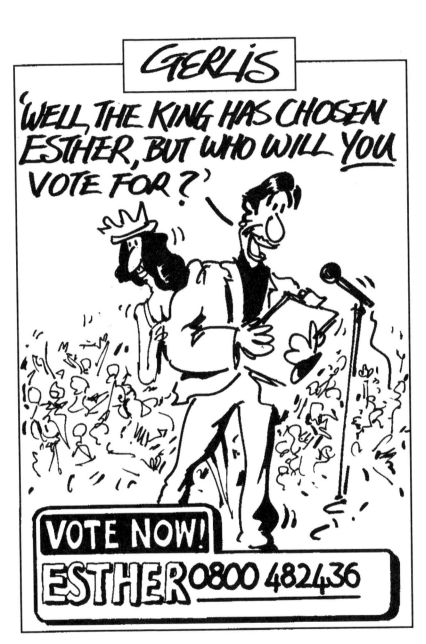

Reality TV shows and the festival of Purim, we were of course swamped with calls
(March 2003)

The appeal of Poppy Day and Chanukah ... I used a new thick pen here but abandoned it soon after (November 2003)

There are seven other *afikomens* (hidden *matzahs*) in the picture (March 2004)

The plagues in Egypt, this my all-time favourite for its sheer simplicity (April 2004)

A sweet little pun on a favourite Jewish custom come the New Year (September 2004)

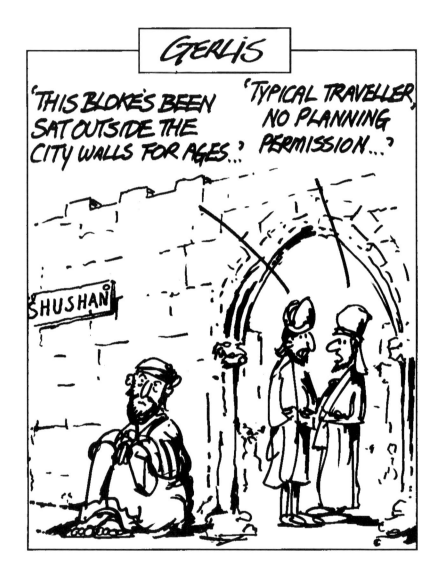

Purim falls in the middle of a debate about 'travellers' buying land (March 2005)

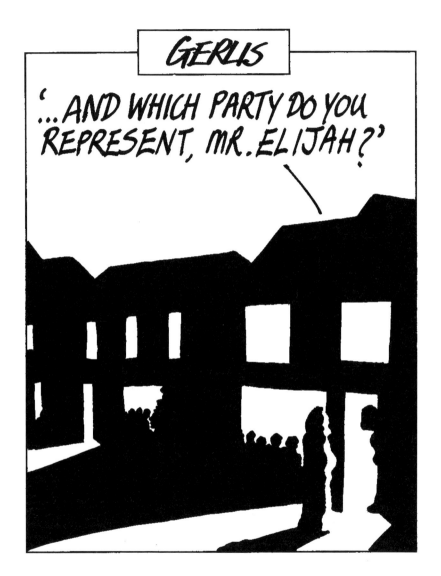

Homage to Magritte as Elijah comes to call during the general election campaign and Pesach (April 2005)

Politics, Feh!

Tony, Gordon, George and Mr Livingstone have been in 'power' virtually the whole time that the cartoon has been running, meanwhile we've had 42 leaders of the Conservative Party including that rare beast, a Jewish politician. I've not been too cruel.

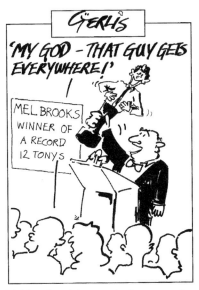

Mel Brooks celebrates winning a record
12th Tony Award, spot the 'Springtime
...' reference (June 2001)

Could almost have done this one at any
time really but things had become bad
between them both ... (January 2005)

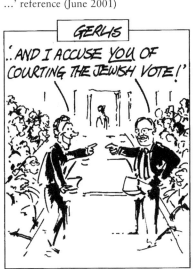

In the middle of the UK general election
campaign both main party leaders slug it
out (March 2005)

... and post-election a new minister is
found to have vaguely friendly views
towards Israel (May 2005)

Still on the Map, Then?

Israel is a tiny country no bigger than the Staines reservoir surrounded by hostile cartoonists, it's a wonder it ever produced 38 Nobel Prize winners, 16 Wimbledon finalists, two Popes and some overpriced mud, but Israelis keep us all amused with their funny ways and we love them for it.

A very early outing for Phyllis as the millennium draws closer (January 1999)

Pleas for communal solidarity find an enthusiastic supporter during the Miss Israel contest (November 2000)

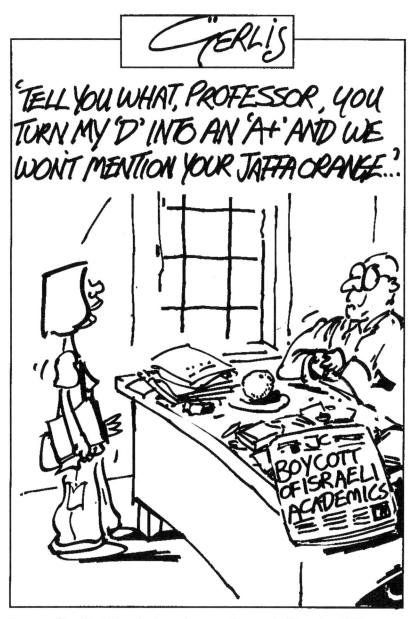

Boycotts of Israel by UK academics surface every few months (December 2002)

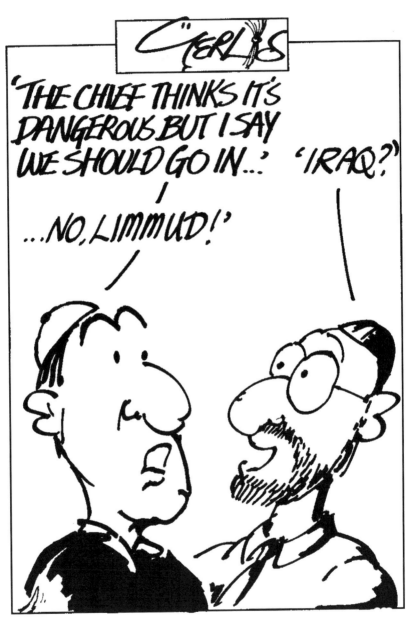

The popularity of Limmud grows in direct proportion to plans to invade Iraq ... and a ponytail (January 2003)

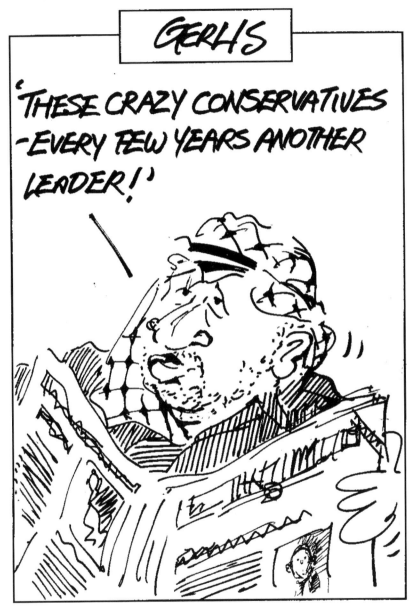

Arafat – the Israelis' and Palestinians' nightmare, the cartoonist's dream – has leadership problems (October 2003)

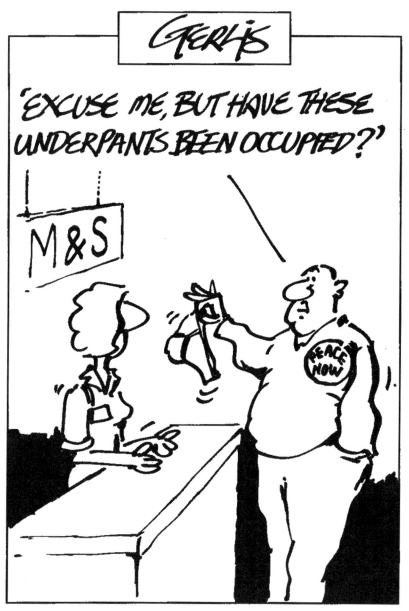

Peace Now suggest that we boycott goods from occupied territories, meanwhile sales decline at M&S (December 2003)

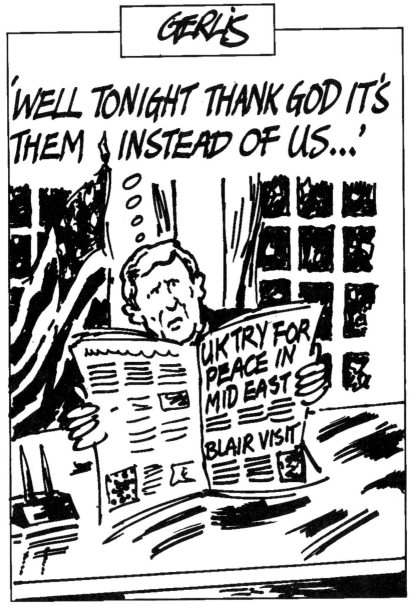

I know, I know, the lyric is wrong as it's the UK's turn to try for peace in the Middle East (December 2004)

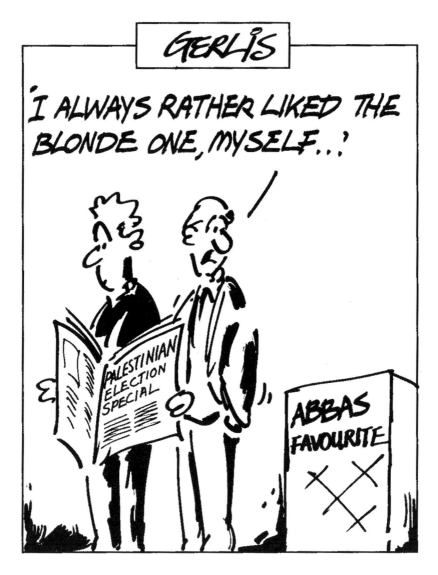

Semi-effective pun featuring Palestinian election candidate and Swedish pop band (January 2005)

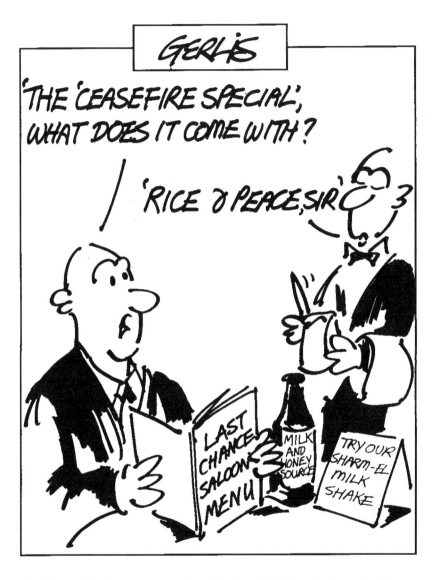

Condaleezza Rice (you're not very nice?) visits the Middle East, check out the other offerings (February 2005)

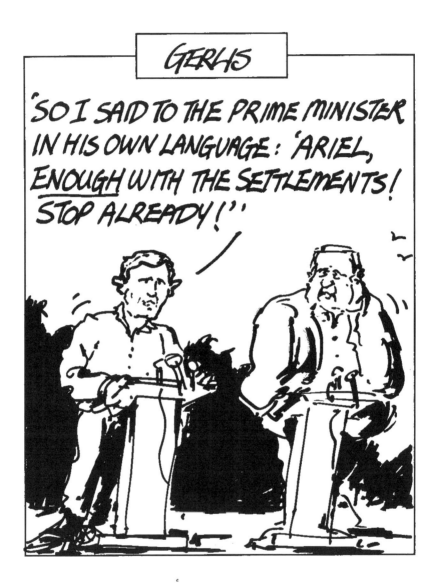

One of my better efforts at drawing Bush and Sharon as they address the press at Bush's ranch (April 2005)

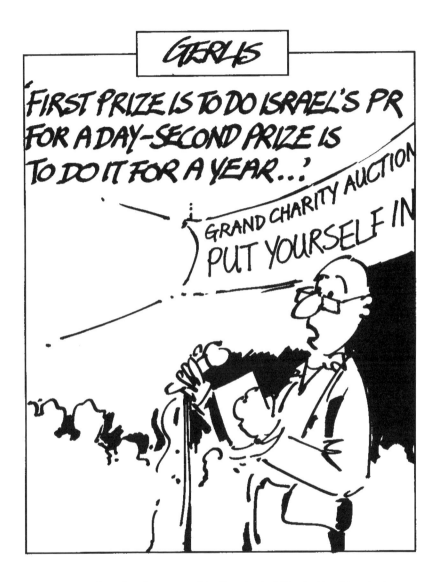

Ongoing issues about Israel's apparent PR efforts in the UK coincide with a charity auction (May 2005)

Chosen for What, Exactly

Apart from the Crusades and Porky Scratchings there are few better subjects for Jewish people to laugh at than the Jewish people themselves – even the good old *JC* has never taken itself too seriously either, which is just as well …

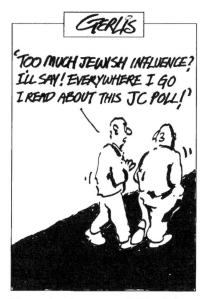

The results of a suppressed EU poll show that people think Jews have too much influence (January 2004)

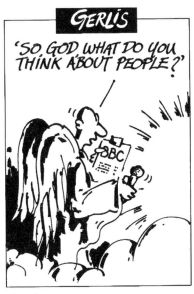

Though omnipresent, God appears specifically in several of the cartoons, in this instance as the BBC asks people what they think of Him/Her (February 2004)

Why do we always answer a question with another question? Why not? (October 2004)

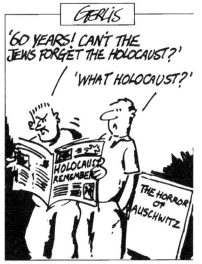

Holocaust Remembrance Day produces slightly harder satire than usual (January 2005)

They Get Paid How Much?

My editor is a Spurs fan and I'm a Grimsby fan, so why did we feature Arsenal so much? Well, they all got a look in here, from Euro 2000 to World Cups etc. Chelsea, Man. Utd, Liverpool and Leeds also got name checks, as did plenty of players, managers and chairmen, Mr Abramovich, sir …

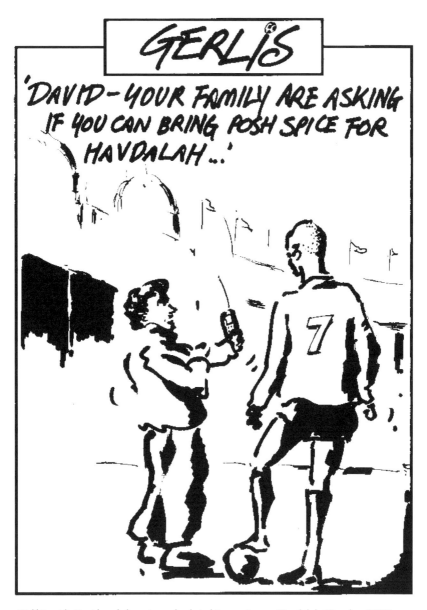

Half-Jewish David and the missus do their bit to spice up Havdalah (October 2000)

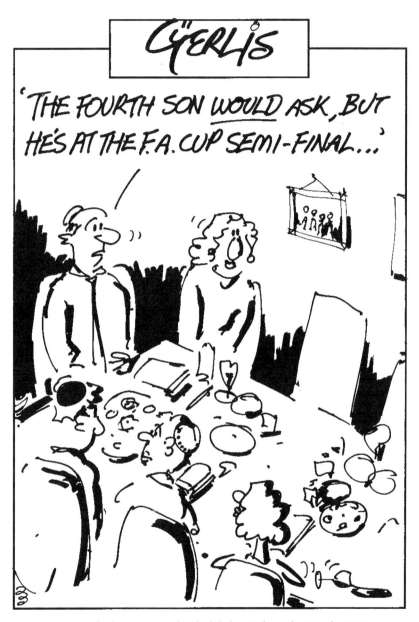

The FA Cup semi-final is conveniently scheduled on Seder night (March 2001)

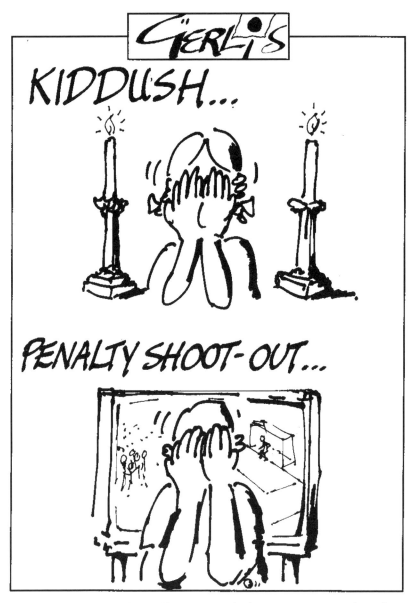

The penalty shoot-out in the World Cup quarter-finals in Japan are on a Friday night (June 2002)

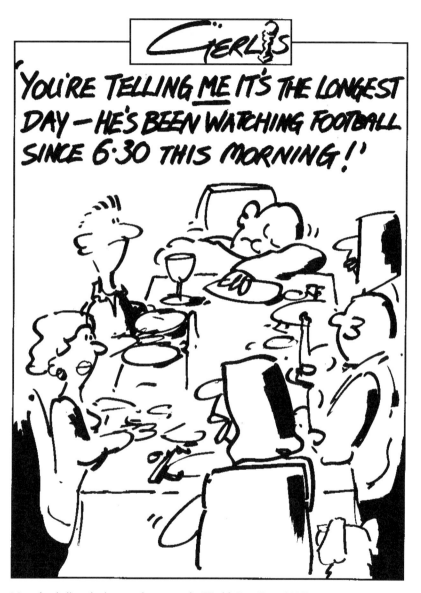

More football as the longest day meets the World Cup (June 2002)

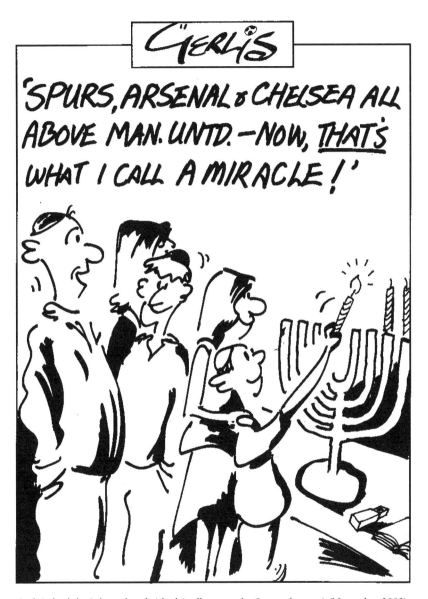

And, indeed that's how they finished (well, except for Spurs of course) (November 2002)

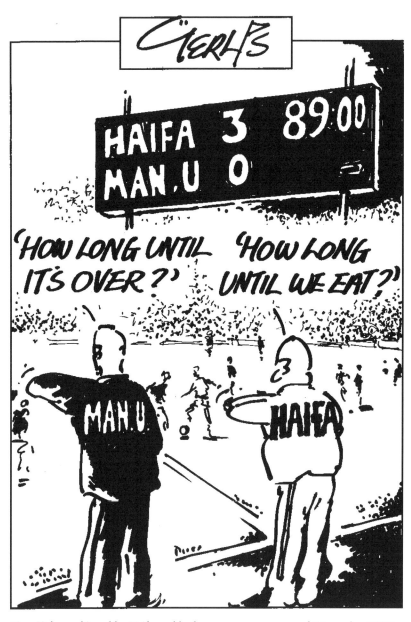

Man. Utd are whipped by Haifa, and both managers are concerned (November 2002)

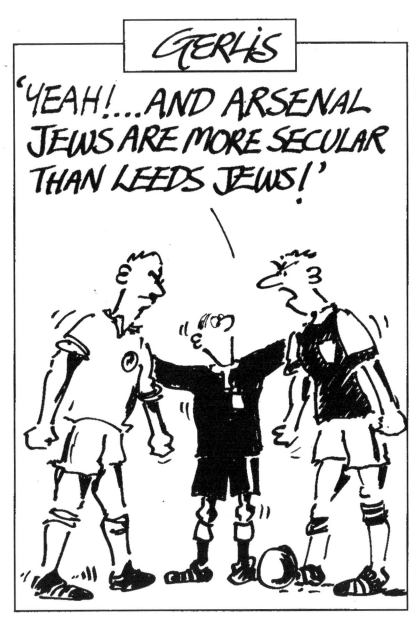

A report reveals that London Jews are more secular than those in the 'provinces', so Leeds v. Arsenal (September 2003)

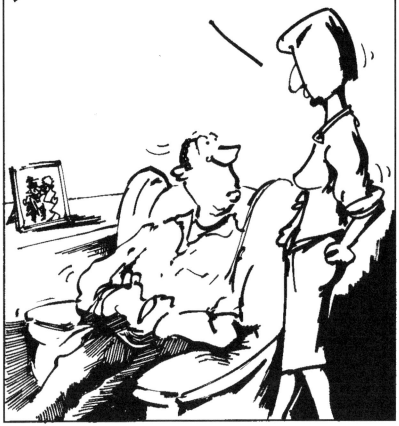

A case before the High Court concerned a man prepared to offer another man money for his wife (May 2003)

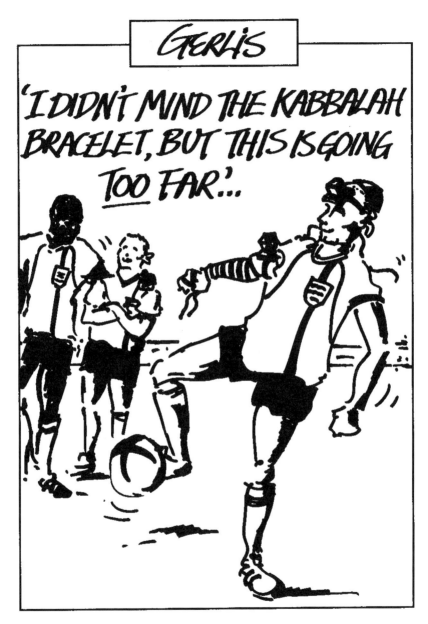

David dons *tefillin* instead of his kabbalah bracelet, a nice one of Rooney and Heskey I thought … (June 2004)

You Look Hungry

The phrase 'Jewish food gags' is almost a cartoon in itself but I've had a go at most things from cheesecake to bagels to tzimmes to chopped liver to falafel to smoked salmon to good old chicken soup – and that's just your starters, so go on … eat up.

This one during Chelsea Flower Show, also a very rare sighting of the Oy Veynus fly trap (May 2000)

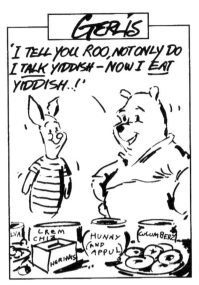

I'd rather have paid homage to E.H. Shepherd than Disney as Pooh is translated into Yiddish, check out the other food offerings (June 2000)

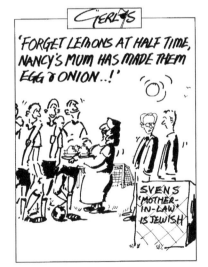

Sven's girlfriend Nancy's Mum is Jewish so it's half time to roll out a food gag (May 2002)

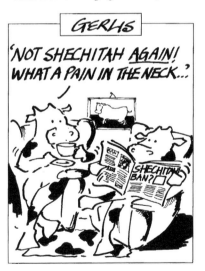

The method of slaughter known as *shechitah* is always under fire, I did lots of gags over the years, this one of the more obvious ones (June 2003)

Men In Beards

Rabbis can be easy pickings for cartoonists and I genuinely tried to avoid just drawing big furry hats, ill-fitting black coats, scowling looks and flowing beards until my mother turned up one hot summer day to inspire me.

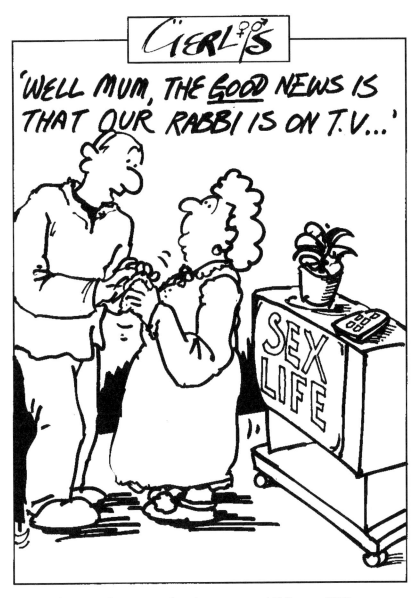

A late night TV sex documentary show features a gay rabbi (January 2002)

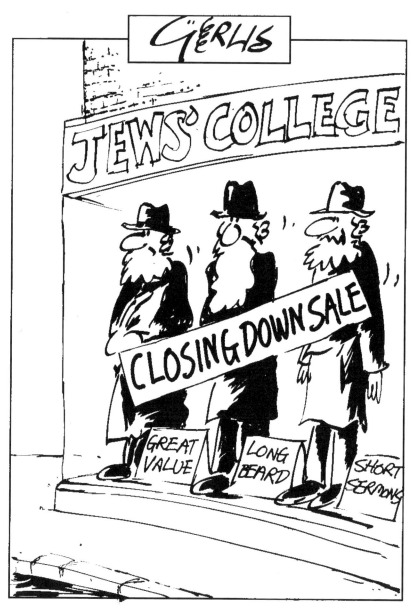

Jews' College is closing down so we do a bit of window shopping (February 2002)

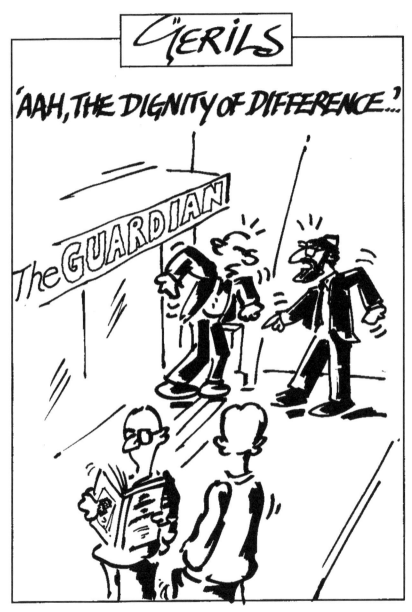

The Chief Rabbi's book *The Dignity of Difference* is the cause of a dispute with the *Guardian* (January 2003)

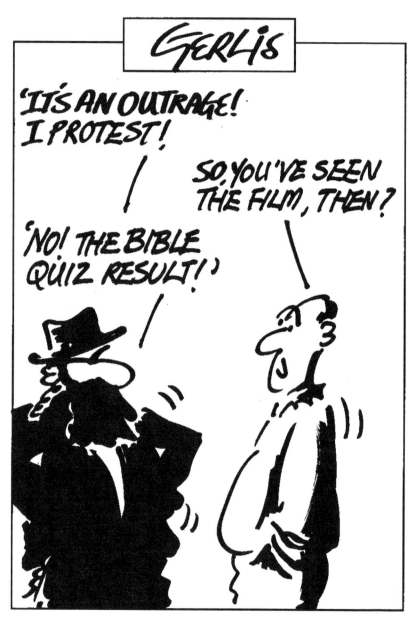

Mel Gibson's film *The Passion* stirs up as much controversy as the result of a recent bible quiz (March 2004)

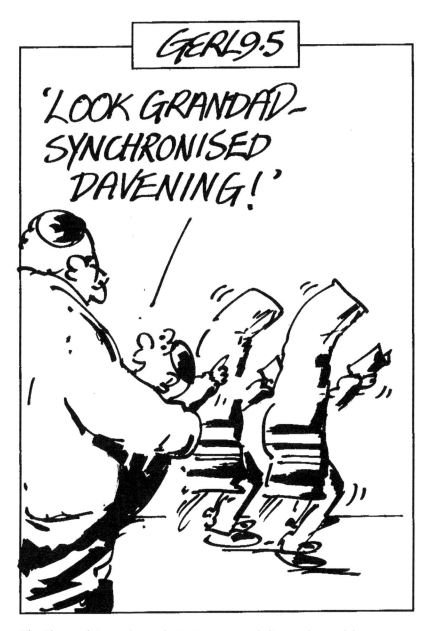

The Olympics bring us the usual minority sports, including synchronised davening (praying/swaying) and a high score, too (August 2004)

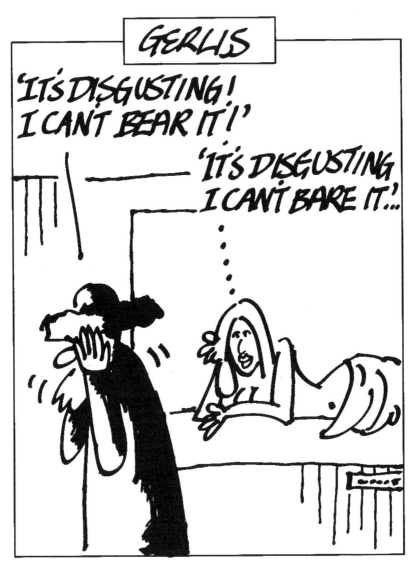

A poster ban in Stamford Hill – does my pun look big in this? Her nipples are overruled but I manage to sneak in some free buttocks (December 2004)

All these stories were technically true, I drew this in New York, hence the little sky-scraper (April 2005)

A Right Little Noah's Ark

We've trained all sorts of animals to appear in the cartoon over the years – horses, Mayors, tortoises, doves and hawks, pigeons, dogs, sacred cows, elephants, reindeer, monkeys ... and none of them were harmed in the process (well, a little embarrassed maybe).

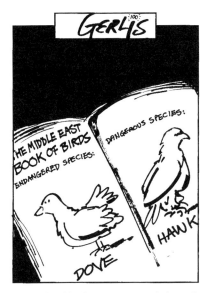

A couple of birds in a rare ornithological guide to the Middle East for the 100th cartoon (October 2000)

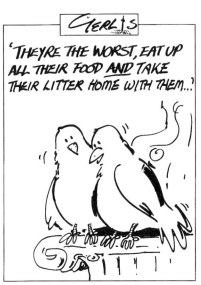

London is a major tourist destination for many Israelis and their picnics (May 2002)

The BBC are often criticised in the *JC* for their 'biased' coverage of Middle East events (November 2003)

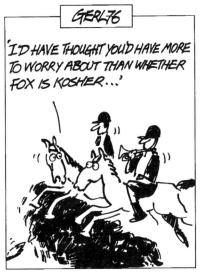

My Mum turned 76 as the hunting debate continues, and no, it's not kosher (December 2004)

Kids – Who Breeds Them?

In my day it was easy – O levels, A levels and a great big grant from the government, nowadays they're doing exams from six months old, they have a mobile by the time they're two and from four onwards they owe £50,000 plus interest ... spoilt I tell you.

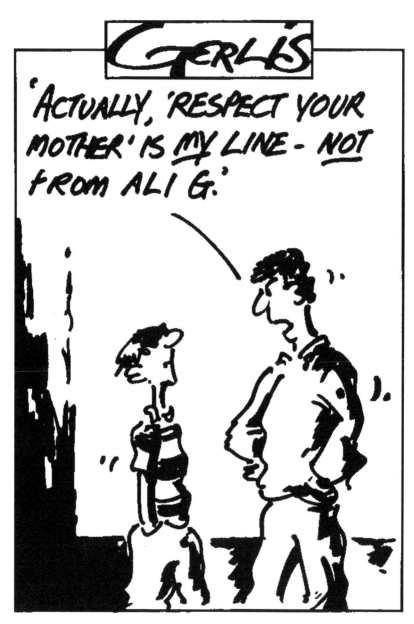

Comedian Sacha Baron Cohen's Ali G character and his catchphrase are becoming ever more popular (January 2000)

We've had quite a few mobiles in the cartoon over the years, this time for the miracle of Chanukah (wait till he gets the bill) (December 2000)

Controversy over two new Jewish schools being planned in the county (July 2002)

Reality TV in the jungle and the start of the new school year (August 2002)

Jewish Aids Trust give out condoms inside student freshers' packs (October 2002)

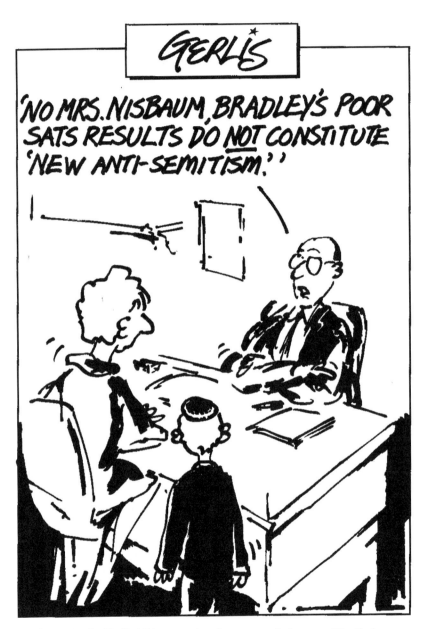

Another outing for Phyllis Nisbaum as she tries to get to the bottom of Bradley's poor results (May 2003)

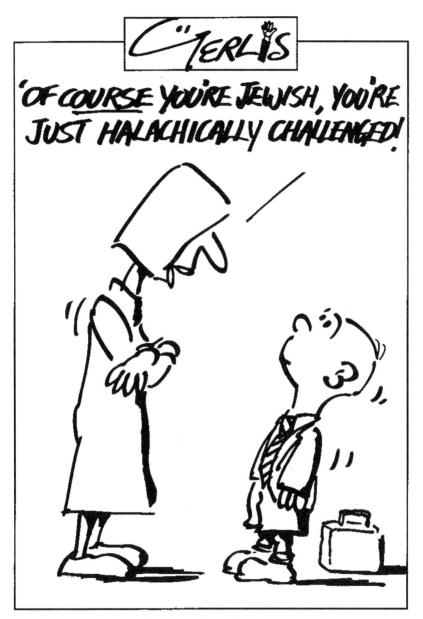

The row continues over whether a non-halachically recognised son is allowed into a Jewish school (May 2003)

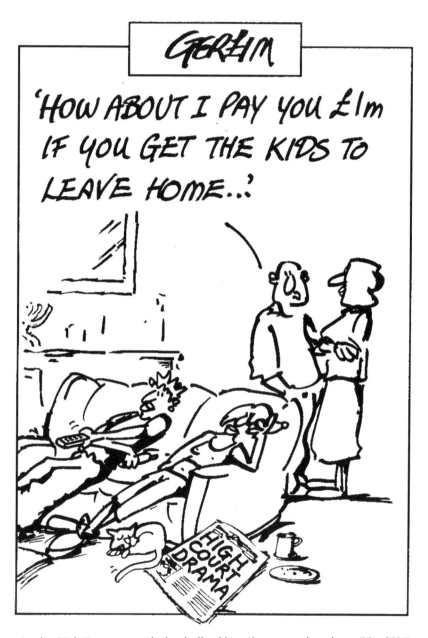

Another High Court case as a husband offered his wife money to leave home (May 2004)

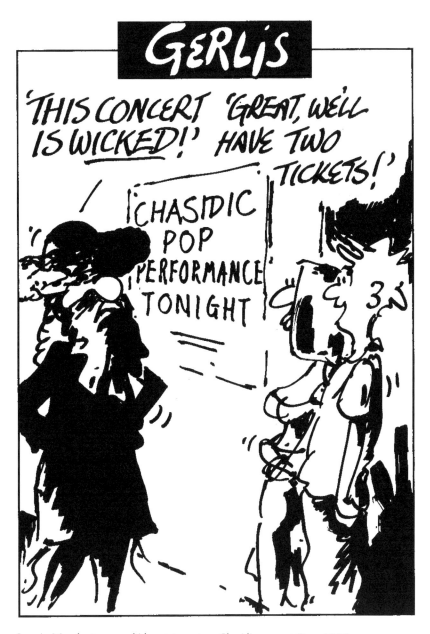

Jews in Manchester warn kids not to go to a Chasidic concert (June 2004)

Farewell, Phyllis Nisbaum …

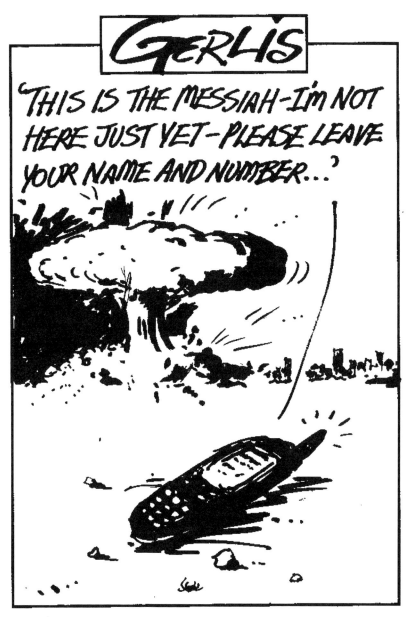

(December 1999)